THE
NATIONAL
GALLERY

POCKET COLLECTION

TEXT BY LEAH KHARIBIAN

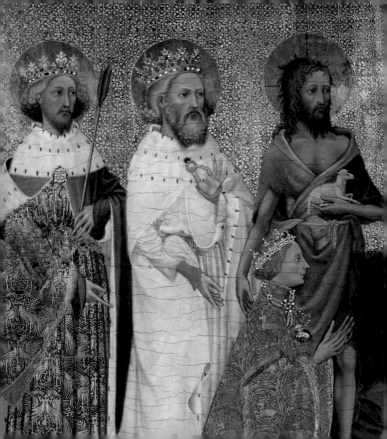

THE
NATIONAL
GALLERY

POCKET COLLECTION

TEXT BY LEAH KHARIBIAN

NATIONAL GALLERY COMPANY,
LONDON

DISTRIBUTED BY YALE UNIVERSITY PRESS

Contents

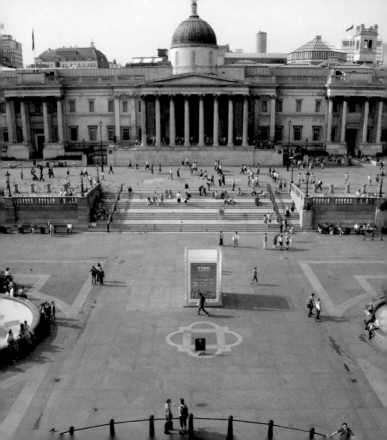

Introduction

Many of the pictures in the National Gallery, London, rank among the finest treasures in the history of western European art. Taking even a brief glance at this little book it's likely you'll see paintings you immediately recognise, be they by van Eyck, Leonardo da Vinci, Titian, Rembrandt, Turner or Van Gogh. The exceptional quality of the National Gallery's Collection makes it one of the greatest picture galleries in the world. With about two thousand pictures, the collection also has an intimate feel to it and many visitors form strong personal bonds with the pictures – even with the fabric of the Gallery itself. It's a place that inspires intense loyalty and affection. But perhaps what most sets the National Gallery apart is the exceptional breadth of its holdings. With works dating from the mid-thirteenth century when painters like Cimabue began to establish picture-making as an independent art form, all the way through to the beginning of the twentieth century when Monet's *Water-Lilies, Setting Sun* took painting to the brink of abstract art, the

Front of The National Gallery, from Trafalgar Square

Gallery holds key works from every major school of western European painting. Nowhere else can a comprehensive history of picture-making – its development, its points of connection and divergence, its moments of startling innovation – be experienced through so many masterpieces. This was, indeed, how the National Gallery was planned.

The National Gallery was founded in 1824 by an Act of Parliament with the clear aim of providing the British public with a collection of pictures of the very highest quality. Furthermore, in contrast to older galleries on the continent, many of which began their lives as princely collections reflecting princely tastes, Britain's new National Gallery would be deliberately wide ranging in scope. Through a careful selection of masterpieces visitors would be presented with the major developments in European art. Painters could use it as a resource and there was much hopeful talk that the pictures might encourage the flowering of a great British school of painting. But far beyond that, the founders firmly believed that such a gathering of pictures would be a universal force for good. The simple act of looking and thinking about fine pictures could be 'an ennobling

enjoyment' for every member of British society – regardless of their profession, rank or income. To that end it was insisted that entry to the Gallery should be free to all. And when in 1838 it came to finding a permanent home for the collection, after its temporary lodgings in Pall Mall, much thought was given to finding a location accessible to all levels of London society. Trafalgar Square, the so-called 'gangway of London', was chosen. This not only put it in the heart of the city but also, importantly, at the meeting point between the well-to-do City of Westminster and the then significantly poorer districts of St-Martin-in-the-Fields and Covent Garden.

Since first opening its doors, the National Gallery's site at Trafalgar Square has quadrupled in size. Successive building programmes, including the ambitious Sainsbury Wing built in the 1980s, have greatly expanded the Gallery space. The initial collection of pictures, which was formed from the acquisition of several important private collections, has also continued to grow. New acquisitions such as Holbein's *Lady with a Squirrel and a Starling* are still chosen on the basis of their outstanding quality, while less well known pictures such as *Lake Kietele* by the nineteenth-century

Finnish artist, Askeli Gallen-Kallela, also fulfil the role of expanding the range of the collection. Entry to the Gallery remains free to all while an active education department provides talks, workshops and programmes that introduce the paintings to ever-wider audiences. Through new technology the Gallery's website and podcasts now offer even greater access to the marvels of the collection and, increasingly, to the impressive body of scholarship generated by the Gallery's curators and members of its Conservation and Scientific departments. What was once intended to be the picture gallery of the Nation is now a gallery of treasures for the study and delight of people the world over.

National Gallery from Pall Mall, 1896

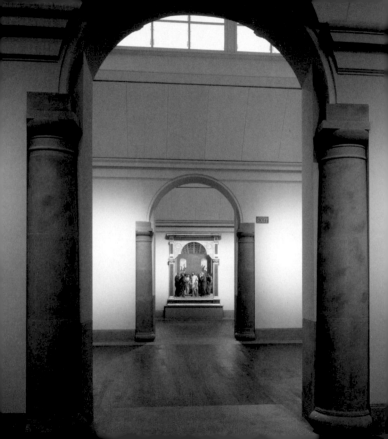

The Sainsbury Wing
1250–1500

Opened in July 1991, the Sainsbury Wing houses the earliest and most fragile pictures in the collection. Displayed in galleries that recall the cool and lofty spaces of fourteenth-century Italian churches, it is, however, a very modern system of light and climate control that keeps these delicate works in optimal conditions. Here the majority of pictures are painted on wooden panels – the earliest form of picture support – and many were made to be part of monumental altarpieces for churches, or parts of smaller, folding works that could be transported by the owner. None were made for picture galleries – the concept didn't exist. Nor were the painters independent artists as we understand the term today. They most often trained and worked in family-run workshops where painting was just one of a number of skills that could have included carpentry, gilding and metalwork. Painting styles between workshops could vary greatly. And as Europe at the time was a patchwork of kingdoms, principalities and city states there were distinct differences between regions, too. But new ideas and

techniques could, and did, spread – even over great distances.

North of the Alps, the technical discovery of mixing pigment with oil brought a revolution in the possibilities of painting. In contrast to the matt, opaque and quick-drying medium of tempera widely used in Italy, where colours were mixed with egg yolk, Netherlandish artists like Jan van Eyck in his *Arnolfini Portrait* led the way in showing how oil paints could be used to render the subtle fall of light and the textures of metal, glass, velvet and fur. The possibility of rendering minutely observed detail in oil was put to great effect in the increasingly popular genre of portraiture. Value was now placed on capturing a true-to-life likeness – even if, as with the Master of the Mornauer Portrait's *Portrait of Alexander Mornauer*, that meant depicting the sitter's wrinkles, double chin and lopsided eyes.

The majority of the pictures in the Sainsbury Wing are devotional works showing scenes from the life of Christ, the Virgin Mary and the Christian saints. Faith dominated European culture throughout this period and the Catholic Church remained art's greatest patron. But from the fourteenth century onwards there developed a new

enthusiasm among rulers and wealthy individuals for intellectual exploration that included a revived interest in the learning and art of Greek and Roman antiquity. This movement, known as the Renaissance, led to even the sacred figures of religious art being depicted in new ways. Giovanni Bellini's *The Agony in the Garden*, for example, shows Christ as a small figure, without a halo, kneeling within a rocky landscape – the barren surroundings reflecting his feelings of loneliness as his disciples sleep in the hours before he is betrayed. This new psychological dimension to painting can also be seen in Piero di Cosimos's *A Satyr mourning over a Nymph*. This work shows the taste among intellectually minded patrons for decorating the furnishings and walls of their homes with scenes drawn from classical mythology that permitted the depiction of idealised nudes, animals, plants and distant landscapes.

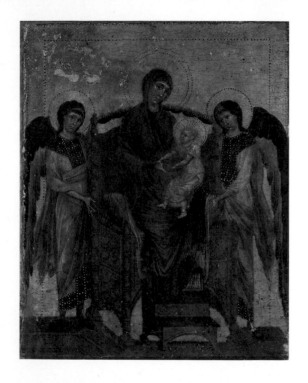

CIMABUE *The Virgin and Child Enthroned with Two Angels* ABOUT 1265–80

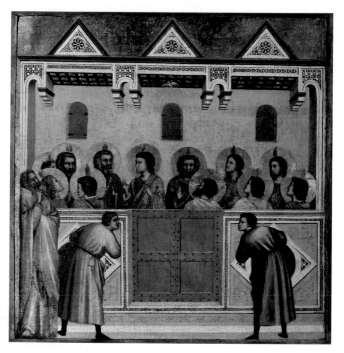

ATTRIBUTED TO GIOTTO DI BONDONE *Pentecost* ABOUT 1306–12

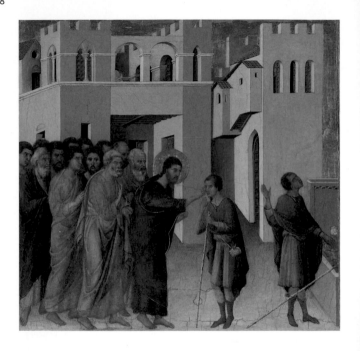

DUCCIO *Jesus opens the Eyes of a Man born Blind* 1311

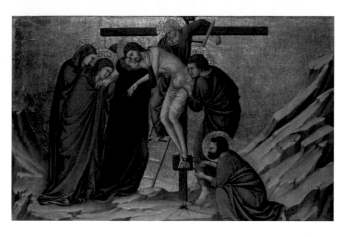

UGOLINO DI NERIO *The Deposition* ABOUT 1324–5

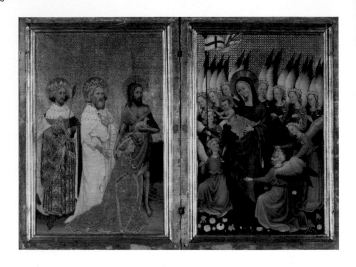

ENGLISH OR FRENCH SCHOOL *The Wilton Diptych* ABOUT 1395–9

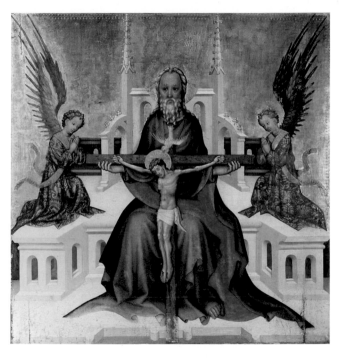

AUSTRIAN SCHOOL *The Trinity with Christ Crucified* ABOUT 1410

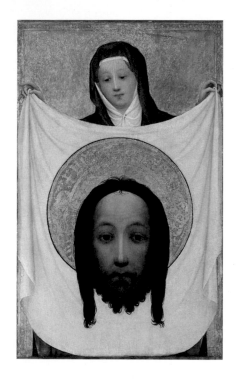

MASTER OF SAINT VERONICA *Saint Veronica with the Sudarium* ABOUT 1420

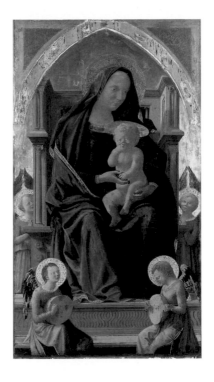

MASACCIO *The Virgin and Child* 1426

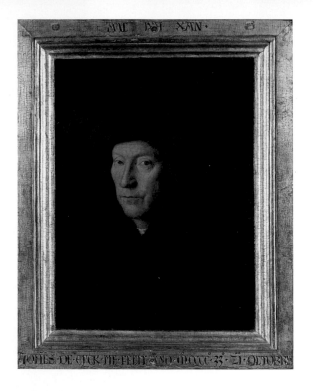

JAN VAN EYCK *Portrait of a Man (Self Portrait?)* 1433

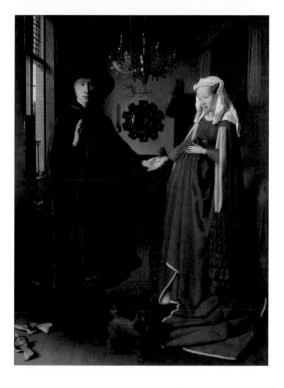

JAN VAN EYCK *The Arnolfini Portrait* 1434

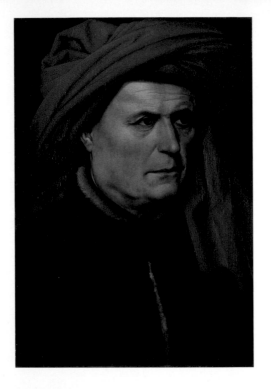

ROBERT CAMPIN *A Man* ABOUT 1435

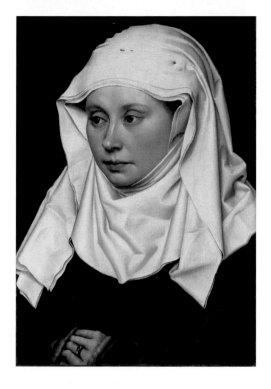

ROBERT CAMPIN *A Woman* ABOUT 1435

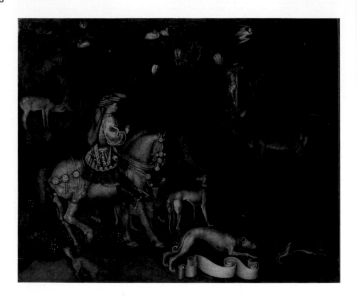

PISANELLO *The Vision of Saint Eustace* ABOUT 1438–42

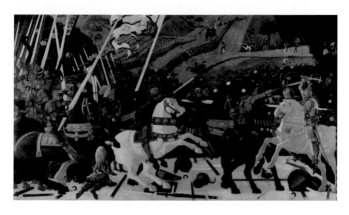

PAOLO UCCELLO *The Battle of San Romano* PROBABLY ABOUT 1438–40

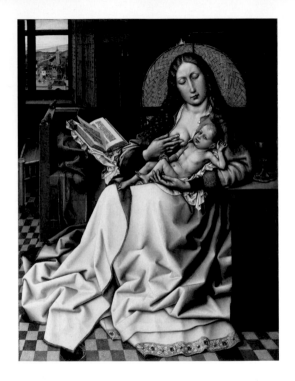

Follower of Robert Campin
The Virgin and Child before a Firescreen about 1440

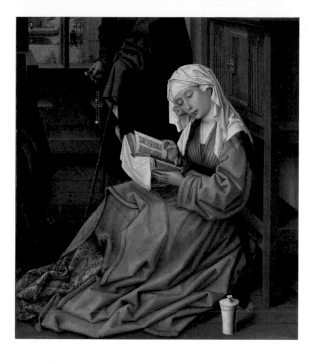

ROGIER VAN DER WEYDEN *The Magdalen Reading* BEFORE 1438

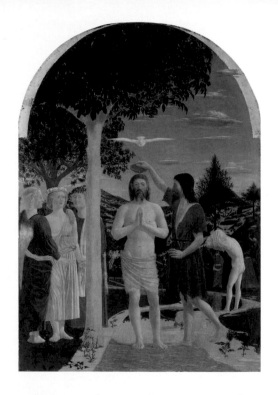

PIERO DELLA FRANCESCA *The Baptism of Christ* 1450s

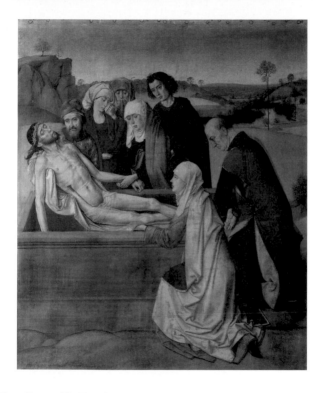

DIRK BOUTS *The Entombment* PROBABLY 1450S

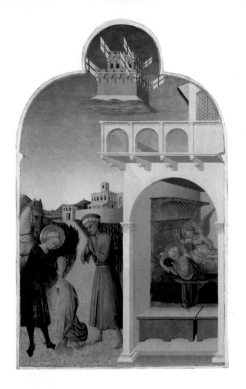

SASSETTA *Saint Francis and the Poor Knight, and Francis's Vision* 1437–44

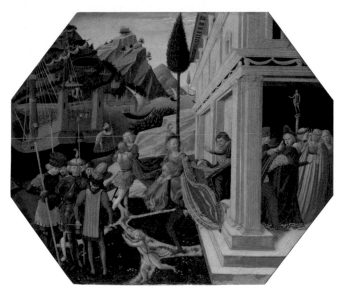

ATTRIBUTED TO ZANOBI STROZZI *The Abduction of Helen* ABOUT 1450–5

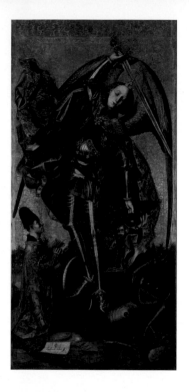

BARTOLOMÉ BERMEJO *Saint Michael Triumphs over the Devil* 1468

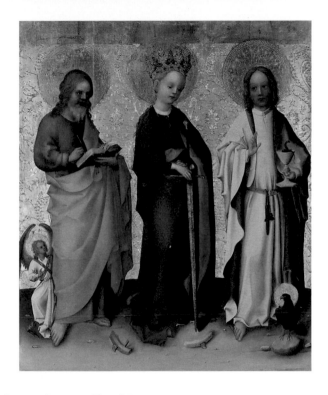

STEPHAN LOCHNER *Three Saints* ABOUT 1450

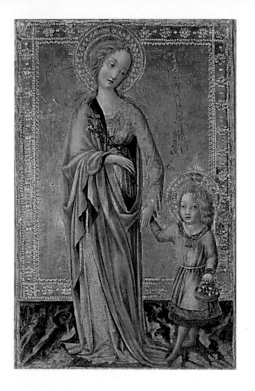

FRANCESCO DI GIORGIO *Saint Dorothy and the Infant Christ* PROBABLY 1460S

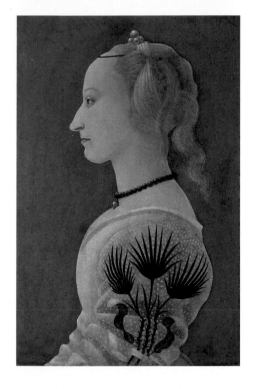

ALESSO BALDOVINETTI *Portrait of a Lady* PROBABLY 1465

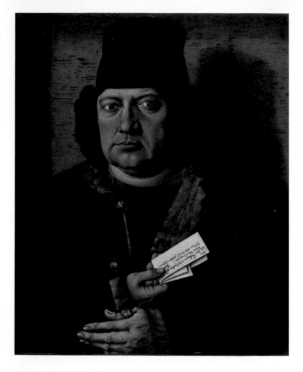

MASTER OF THE MORNAUER PORTRAIT
Portrait of Alexander Mornauer ABOUT 1464–88

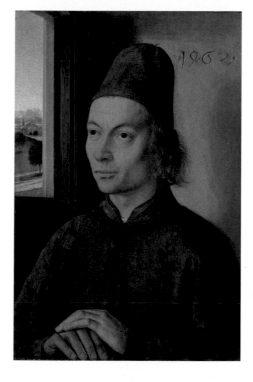

DIRK BOUTS *Portrait of a Man (Jan van Winckele?)* 1462

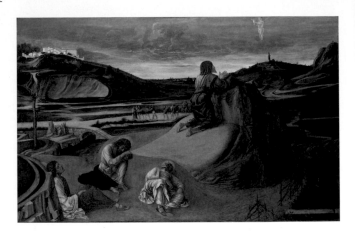

GIOVANNI BELLINI *The Agony in the Garden* ABOUT 1465

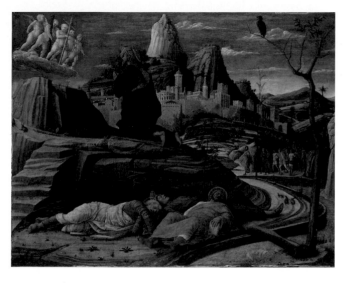

ANDREA MANTEGNA *The Agony in the Garden* ABOUT 1460

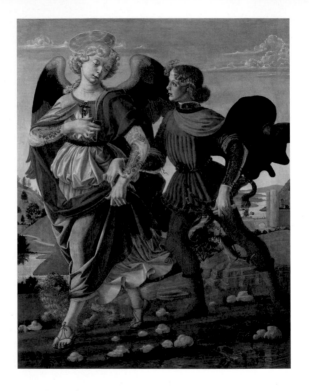

Workshop of Andrea del Verrocchio *Tobias and the Angel* 1470–80

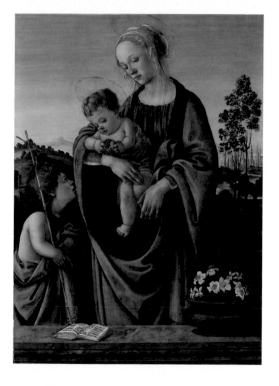

FILIPPINO LIPPI *The Virgin and Child with Saint John* ABOUT 1480

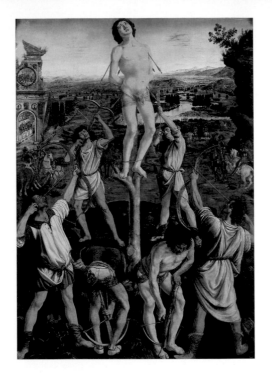

ANTONIO AND PIERO DEL POLLAIUOLO
The Martyrdom of Saint Sebastian COMPLETED 1475

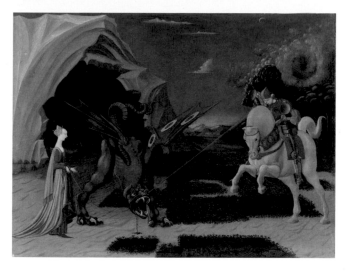

PAOLO UCCELLO *Saint George and the Dragon* ABOUT 1470

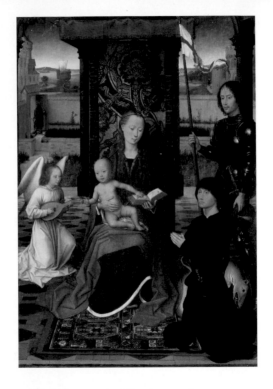

HANS MEMLING *The Virgin and Child with an Angel* ABOUT 1480

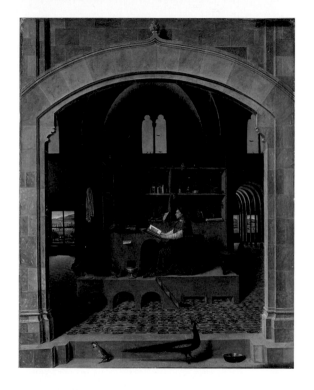

ANTONELLO DA MESSINA *Saint Jerome in his Study* ABOUT 1475

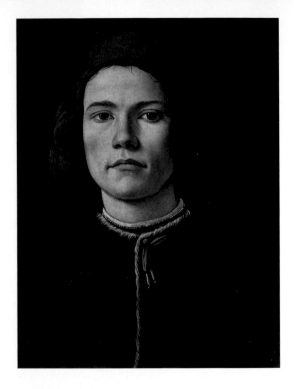

SANDRO BOTTICELLI *Portrait of a Young Man* PROBABLY ABOUT 1480–5

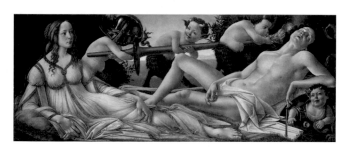

SANDRO BOTTICELLI *Venus and Mars* ABOUT 1485

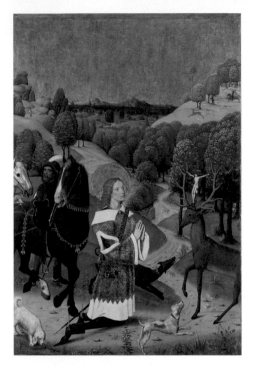

MASTER OF THE LIFE OF THE VIRGIN
The Conversion of Saint Hubert: Left Hand Shutter PROBABLY ABOUT 1480–5

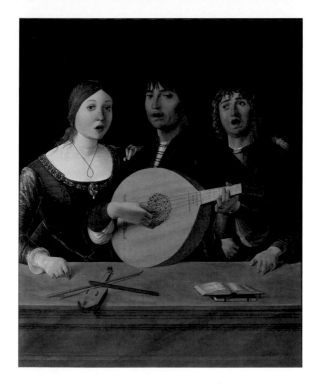

LORENZO COSTA *A Concert* ABOUT 1485–95

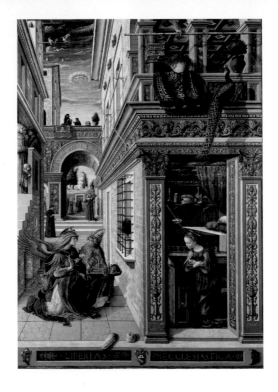

CARLO CRIVELLI *The Annunciation, with Saint Emidius* 1486

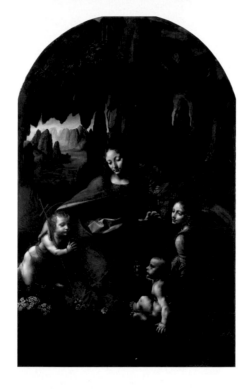

LEONARDO DA VINCI *The Virgin of the Rocks* ABOUT 1491–1508

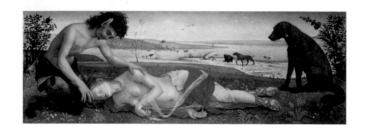

PIERO DI COSIMO *A Satyr mourning over a Nymph* ABOUT 1495

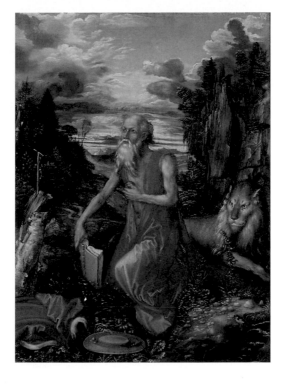

ALBRECHT DÜRER *Saint Jerome* ABOUT 1496

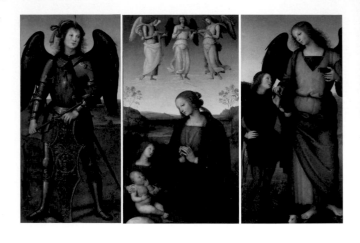

PIETRO PERUGINO
Three Panels from a Certosa Altarpiece, Pavia ABOUT 1496–1500

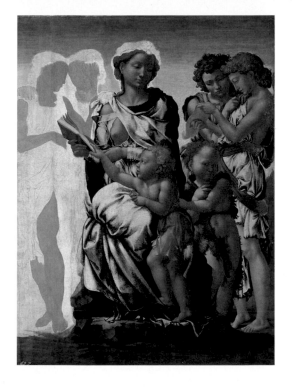

Michelangelo *'The Manchester Madonna'* about 1497

The West Wing
1500–1600

The West Wing is the oldest part of the National Gallery and its grand rooms, lit by skylights and decorated with richly coloured fabrics, offer a fittingly palatial setting for some of the largest and most highly prized works in the collection. Here the development of the Renaissance as it flowered in various artistic centres throughout the sixteenth century can be traced through an astonishing array of masterpieces. Leonardo da Vinci's cartoon, Michelangelo's unfinished *Entombment* and Raphael's *Saint Catherine of Alexandria*, for example, all show how drawing, the study of antique sculpture and the aspiration to balance, harmony and ideal beauty lay at the heart of painting in Florence and Rome. In Venice, trading links with the east that brought exotic pigments and rich fabrics to the city helped give impetus to a different approach to painting. Dazzling colours and a more expressive use of the medium of paint – now often applied to canvas – resulted in works of tremendous visual impact. The intense colours and emotion of Titian's love-at-first-sight encounter depicted in *Bacchus and Ariadne* and the

dramatic action and aerial perspective of Tintoretto's *Saint George and the Dragon*, demonstrated entirely new possibilities for painting.

North of the Alps exquisitely observed portraiture continued to flourish and play an increasingly important role in the politics of court life. The status of individual painters was now such that a renowned portraitist like Holbein had an international standing. He was in Britain, working at the court of Henry VIII, when he painted *The Ambassadors* – a monumental work that documents, among other things, the fraught diplomatic efforts to heal the rift brought about by King Henry's split with the Catholic Church in Rome. The division of the Christian Church between the Catholics and the reforming Protestants gathered pace throughout the sixteenth century and would have a profound effect on art.

New patterns of collecting and displaying pictures – which included filling cabinet rooms with smaller works for private enjoyment – encouraged the development of new types of painting. In Venice Giorgione made one of the first forays into pure depictions of landscape with works like *Il Tramonto (The Sunset)*. Cranach, who

worked for the Saxon Court, created titillating, small-scale images of the classical goddess Venus. Other artists began turning to scenes of everyday life for inspiration to create what is called genre painting. The Flemish artist, Joachim Beuckelaer, shows a lively market scene in *The Four Elements: Air* while the Italian Giovanni Battista Moroni lavishes all the care and attention he might on a princely sitter in depicting an anonymous working man, *The Tailor ('Il Taliapanni')*.

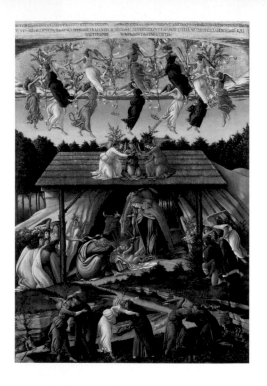

SANDRO BOTTICELLI '*Mystic Nativity*' 1500

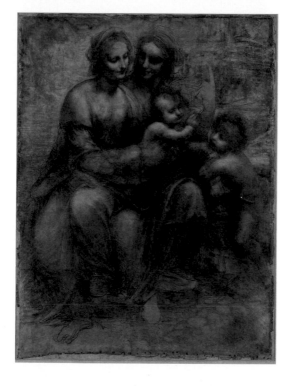

LEONARDO DA VINCI *The Leonardo Cartoon* ABOUT 1499–1500

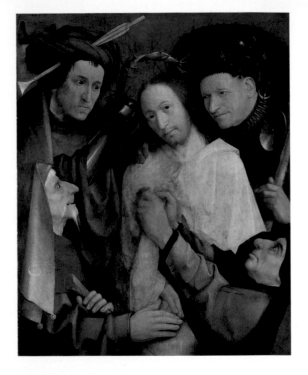

HIERONYMUS BOSCH
Christ Mocked (The Crowning with Thorns) ABOUT 1490–1500

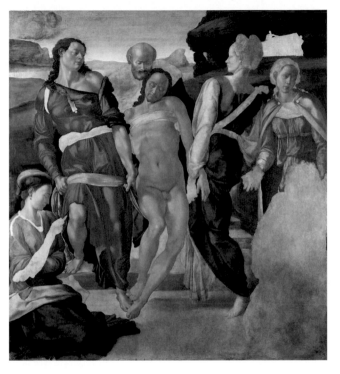

MICHELANGELO *The Entombment* ABOUT 1500–1

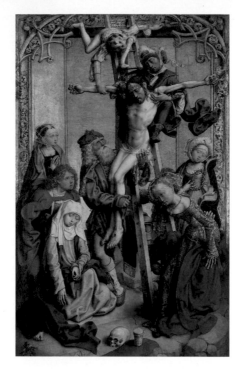

MASTER OF THE SAINT BARTHOLOMEW ALTARPIECE
The Deposition ABOUT 1500–5

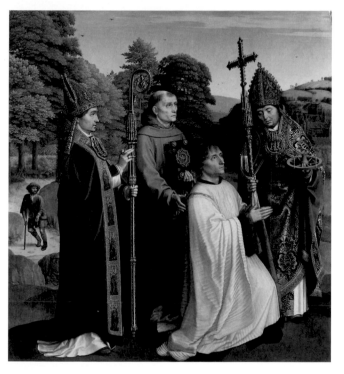

GERARD DAVID *Canon Bernardijn Salviati and Three Saints* AFTER 1501

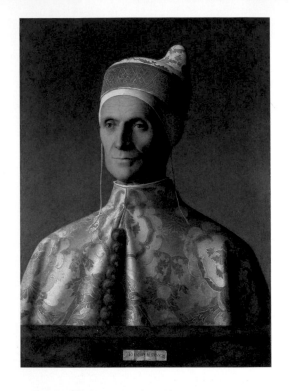

GIOVANNI BELLINI *The Doge Leonardo Loredan* 1501–4

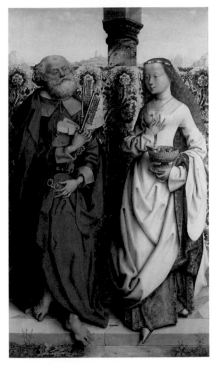

MASTER OF THE SAINT BARTHOLOMEW ALTARPIECE
Saints Peter and Dorothy PROBABLY 1505–10

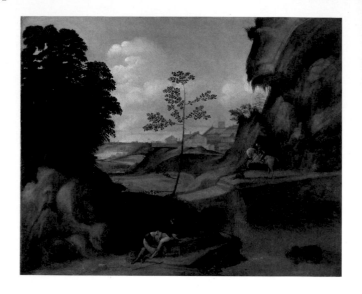

GIORGIONE *Il Tramonto (The Sunset)* 1506–10

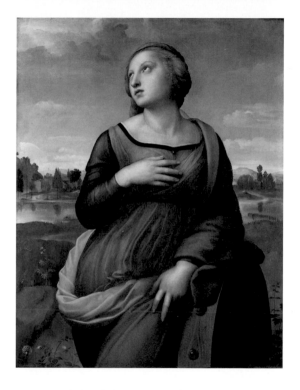

Raphael *Saint Catherine of Alexandria* about 1507

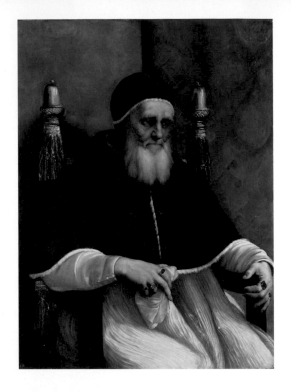

Raphael *Portrait of Pope Julius II* MID-1511

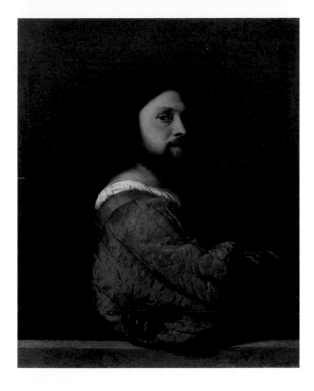

TITIAN *A Man with a Quilted Sleeve* ABOUT 1510

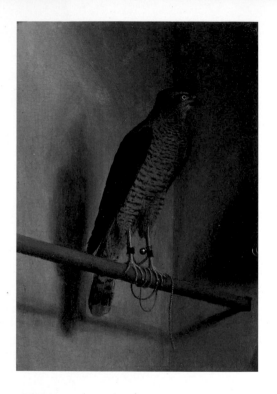

JACOPO DE' BARBARI *A Sparrowhawk* 1510s

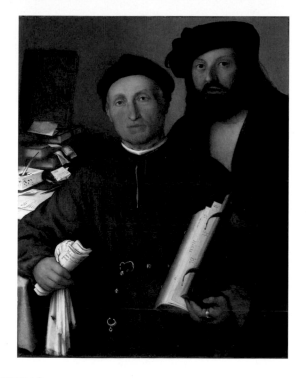

LORENZO LOTTO
Giovanni Agostino della Torre and his Son, Niccolò ABOUT 1513–16

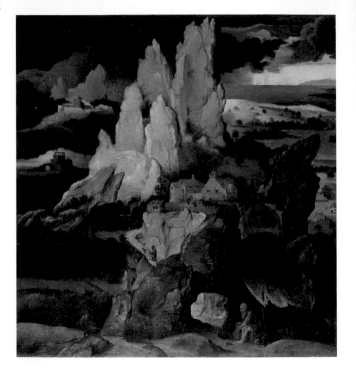

ATTRIBUTED TO THE WORKSHOP OF JOACHIM PATINIR
Saint Jerome in a Rocky Landscape PROBABLY 1515–24

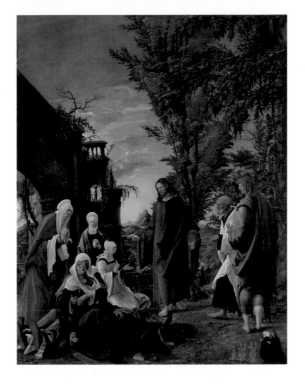

Albrecht Altdorfer *Christ taking Leave of his Mother* probably 1520

80

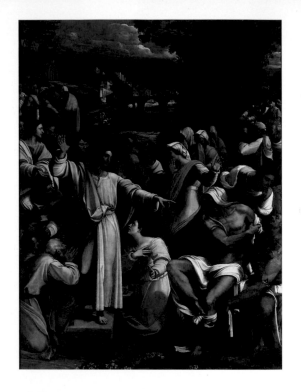

Sebastiano del Piombo *The Raising of Lazarus* ABOUT 1517–19

PONTORMO *Joseph sold to Potiphar* ABOUT 1515

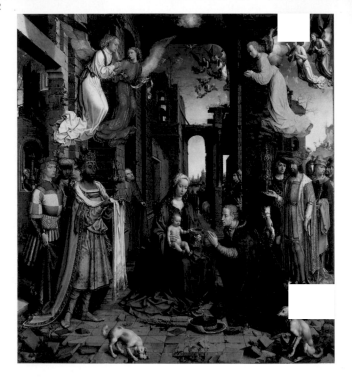

JAN GOSSAERT *The Adoration of the Kings* 1510–5

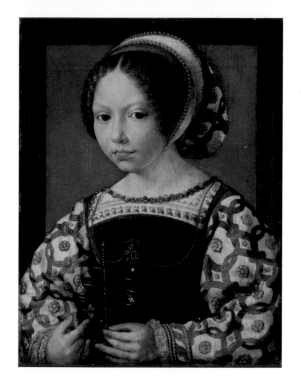

JAN GOSSAERT *A Little Girl* ABOUT 1520

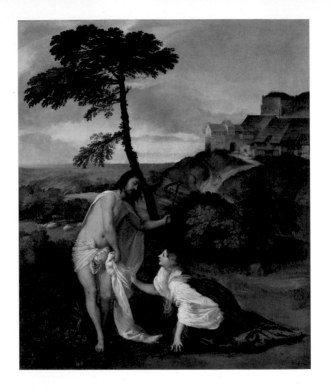

TITIAN *Noli me Tangere* ABOUT 1514

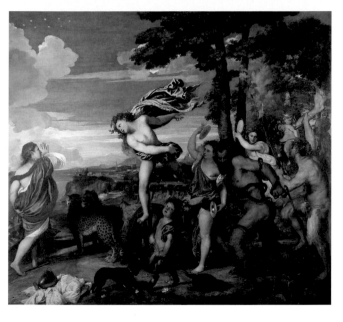

TITIAN *Bacchus and Ariadne* 1520–3

LUCAS CRANACH THE ELDER
Portrait of Johann Friedrich the Magnanimous 1509

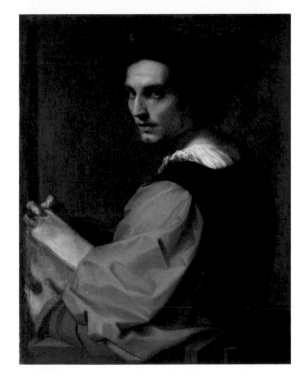

ANDREA DEL SARTO *Portrait of a Young Man* ABOUT 1517–18

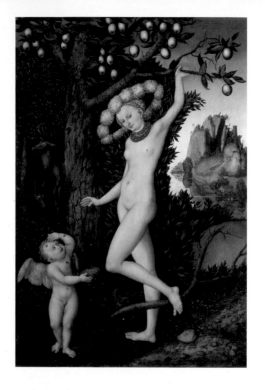

Lucas Cranach the Elder *Cupid complaining to Venus* about 1525

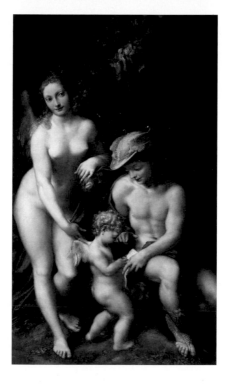

CORREGGIO *Venus with Mercury and Cupid ('The School of Love')* ABOUT 1525

Lorenzo Lotto *Portrait of a Woman inspired by Lucretia* about 1530–2

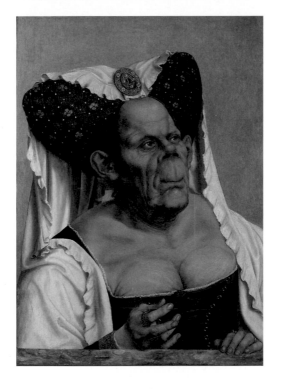

ATTRIBUTED TO QUINTEN MASSYS *A Grotesque Old Woman* ABOUT 1525–30

PARMIGIANINO *The Madonna and Child with Saints* 1526–7

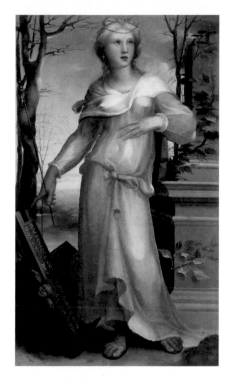

DOMENICO BECCAFUMI *Tanaquil* PROBABLY ABOUT 1520–5

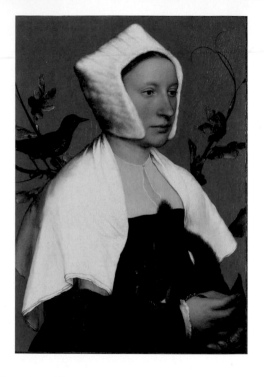

Hans Holbein the Younger
A Lady with a Squirrel and a Starling (Anne Lovell?) about 1526–8

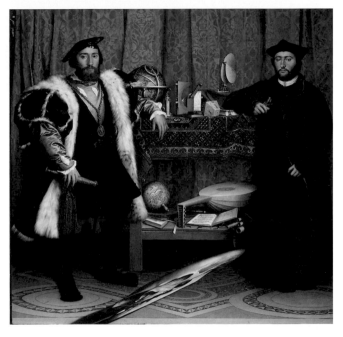

HANS HOLBEIN THE YOUNGER *'The Ambassadors'* 1533

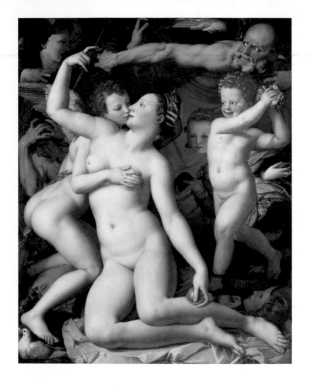

BRONZINO *An Allegory with Venus and Cupid* PROBABLY 1540–50

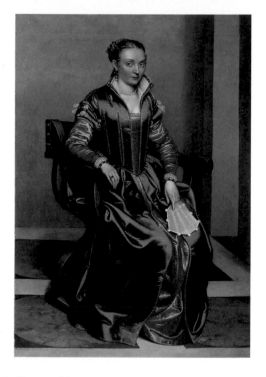

GIOVANNI BATTISTA MORONI
Portrait of a Lady ('La Dama in Rosso') ABOUT 1556–60

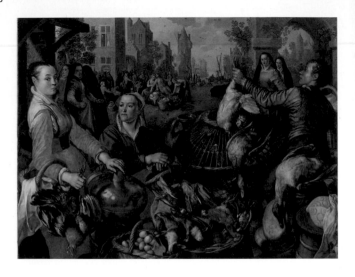

JOACHIM BEUCKELAER *The Four Elements: Air* 1570

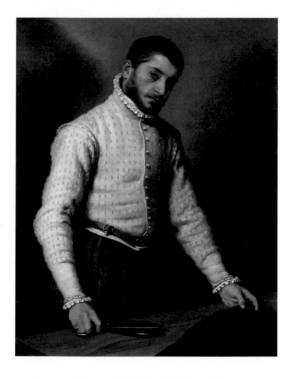

GIOVANNI BATTISTA MORONI *The Tailor ('Il Tagliapanni')* ABOUT 1565–70

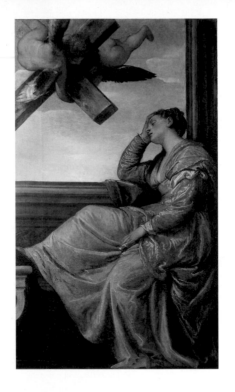

PAOLO VERONESE *The Vision of Saint Helena* ABOUT 1560–5

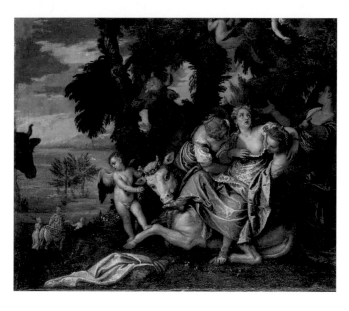

PAOLO VERONESE *The Rape of Europa* ABOUT 1570

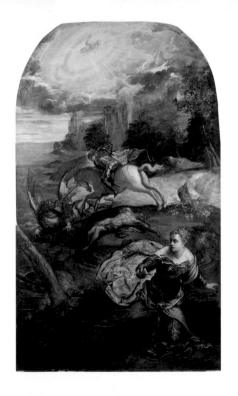

JACOPO TINTORETTO *Saint George and the Dragon* ABOUT 1560

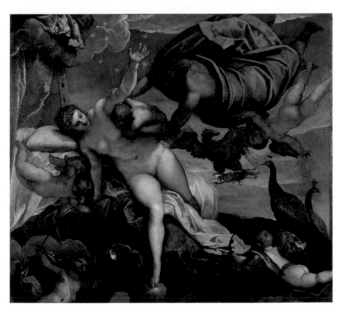

Jacopo Tintoretto *The Origin of the Milky Way* ABOUT 1575

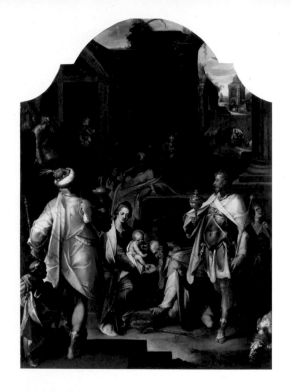

BARTHOLOMAEUS SPRANGER *The Adoration of the Kings* ABOUT 1595

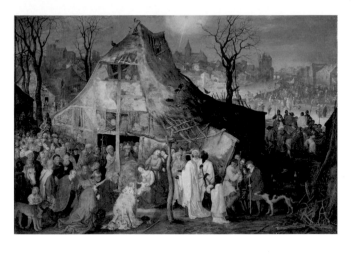

JAN BRUEGHEL THE ELDER *The Adoration of the Kings* 1598

THE MOND ROOM

The North Wing
1600–1700

The North Wing of the Gallery presents the visitor with enormous contrasts both in terms of the type of pictures it displays and the scale of the rooms that house them. In the large galleries many of the pictures show the high emotion, violent action and dramatic light effects that have become associated with the movement known as the Baroque. Here in Caravaggio's *The Supper at Emmaus*, the outstretched arm of the disciple on the right threatens to burst out of the picture, while in Rubens's *Samson and Delilah* the Old Testament tale of lust and betrayal takes place by flickering torch-light. During this period the Catholic Church in Rome, wishing to stem the growth in Protestantism, called for devotional works that might reclaim the hearts as well as the minds of the faithful. Guercino's *The Dead Christ Mourned by Two Angels* is a work designed to stir intense pity and remorse in the viewer, while in Spain – where any dissent from the established Roman Cathloic faith was suppressed with particular harshness – Zurbarán's *Saint Francis in Meditation* promotes an ecstatic form of religious fervour.

At the same time that the Catholic Church was attempting to use art in the fight for religious dominance in Europe, Italy – and most particularly Rome itself – was becoming the prime destination for young artists wishing to complete their training. A study of the antiquities, churches and picture galleries of the 'Eternal City' was deemed essential – even for established artists like Velázquez who was sent to Italy by his patron, King Philip IV of Spain. The French even established their own academy in Rome to which its most promising art students were sent. And foreign painters resident in the city, such as Poussin and Claude, established a form of painting that fused idealised Italian landscape and antique references that became the European benchmark of artistic excellence.

In the Protestant countries of the north, other less idealised forms of painting began to flourish, many of which were smaller in scale and more intimate in subject matter. Rembrandt, who earned his living chiefly through painting portraits, embarked on a series of searching studies of himself, perhaps the most famous of which is the National Gallery's *Self Portrait at the Age of 34*. Other Dutch artists made close studies of the routines and spaces of everyday domestic life, and these

are hung in the smallest rooms of the Gallery. De Hooch's *The Courtyard of a House in Delft* lovingly depicts the worn brickwork and rotting plaster of his urban surroundings, while Vermeer's *Young Woman standing at a Virginal* captures the subtle fall of light on the luxurious surfaces of a gilt frame, the woman's satin gown and the velvet upholstery of the foreground chair. Meticulous observation and illusionistic skill were highly prized. Among the new genres of pictures that found eager markets were seascapes, landscapes, and the new genres of still life and flower painting where moralising on the brevity of life was subtly mixed with sumptuous depictions of objects of luxury.

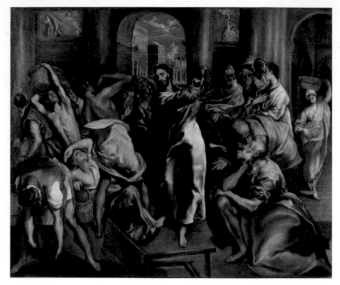

EL GRECO *Christ driving the Traders from the Temple* ABOUT 1600

ANNIBALE CARRACCI *Christ appearing to Saint Peter on the Appian Way* 1601–2

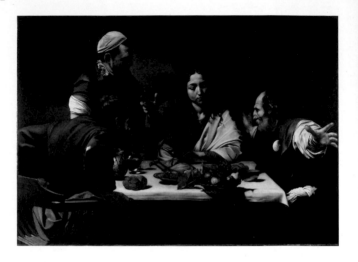

CARAVAGGIO *The Supper at Emmaus* 1601

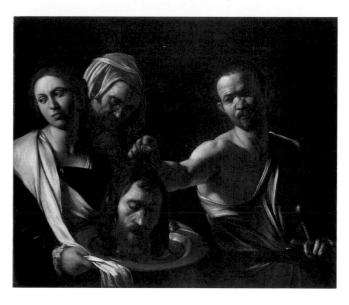

CARAVAGGIO *Salome receives the Head of Saint John the Baptist* 1607–10

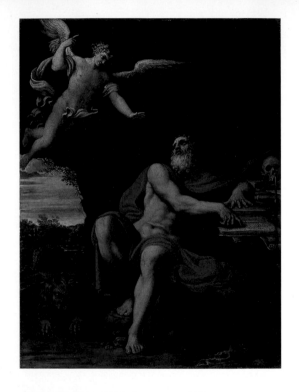

DOMENICHINO *The Vision of Saint Jerome* BEFORE 1603

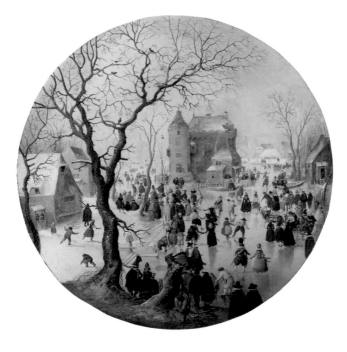

HENDRICK AVERCAMP *A Winter Scene with Skaters near a Castle* ABOUT 1608–9

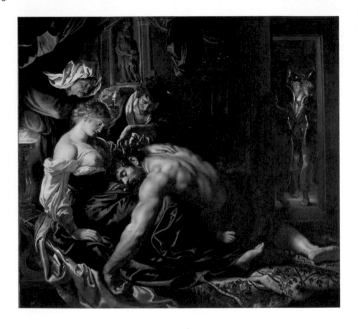

PETER PAUL RUBENS *Samson and Delilah* ABOUT 1609–10

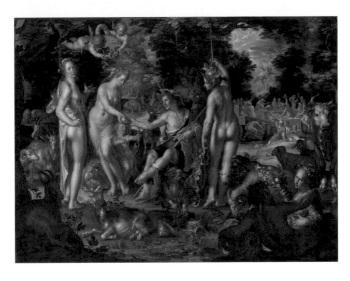

JOACHIM WTEWAEL *The Judgement of Paris* 1615

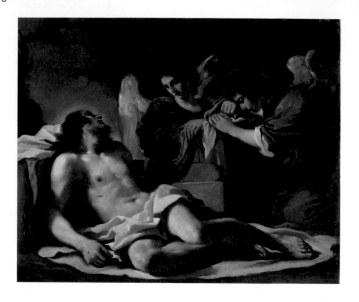

GUERCINO *The Dead Christ mourned by Two Angels* ABOUT 1617–18

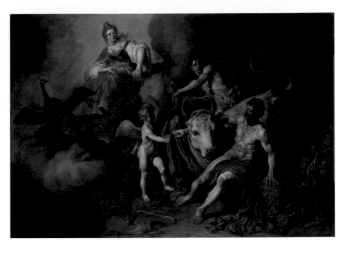

PIETER LASTMAN *Juno discovering Jupiter with Io* 1618

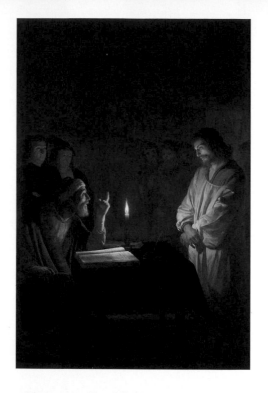

GERRIT VAN HONTHORST *Christ before the High Priest* ABOUT 1617

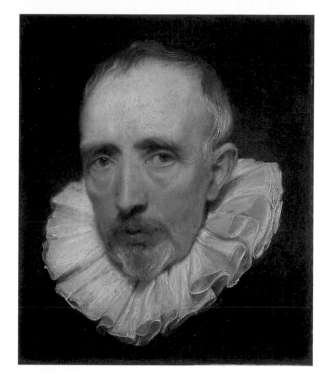

Anthony van Dyck *Portrait of Cornelis van der Geest* about 1620

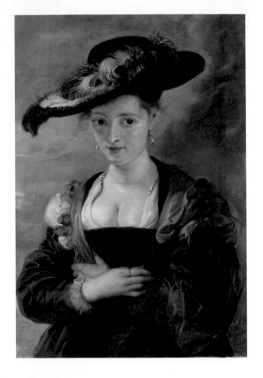

PETER PAUL RUBENS
Portrait of Susanna Lunden(?) ('Le Chapeau de Paille') PROBABLY 1622–5

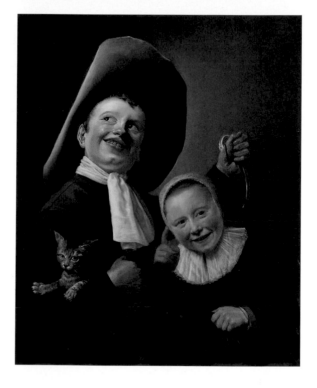

Judith Leyster *A Boy and a Girl with a Cat and an Eel* about 1635

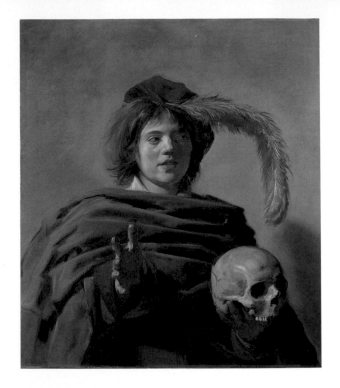

FRANS HALS *Young Man holding a Skull (Vanitas)* 1626–8

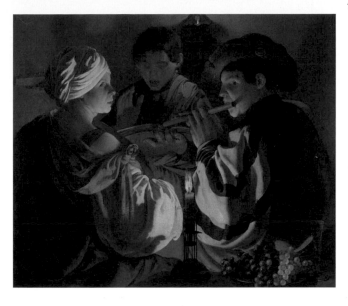

HENDRICK TER BRUGGHEN *The Concert* ABOUT 1626

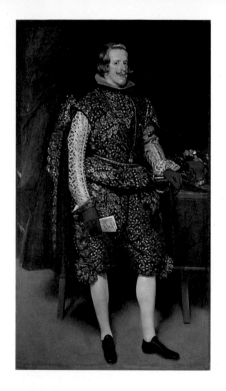

Diego Velázquez *Philip IV of Spain in Brown and Silver* ABOUT 1631–2

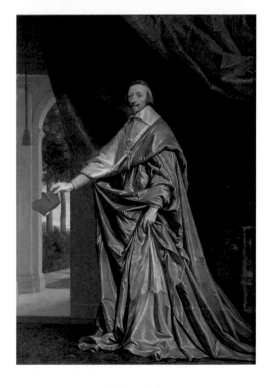

PHILIPPE DE CHAMPAIGNE *Cardinal de Richelieu* 1633–40

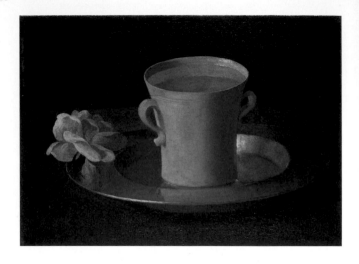

Francisco de Zurbarán *A Cup of Water and a Rose* about 1630

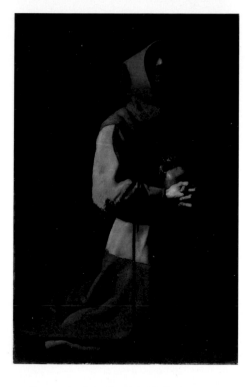

Francisco de Zurbarán *Saint Francis in Meditation* 1635–9

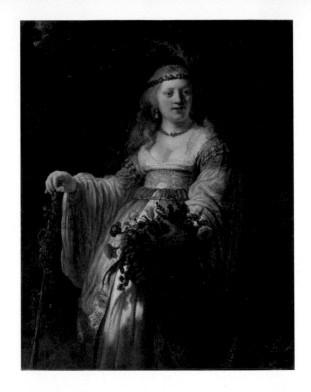

REMBRANDT *Saskia van Uylenburgh in Arcadian Costume* 1635

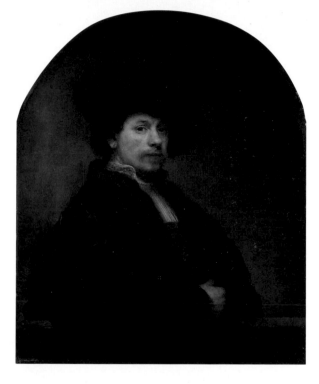

REMBRANDT *Self Portrait at the Age of 34* 1640

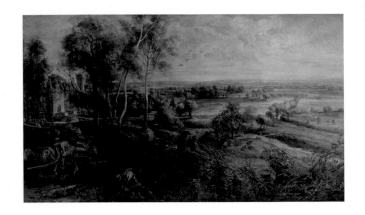

PETER PAUL RUBENS *A View of Het Steen in the Early Morning* PROBABLY 1636

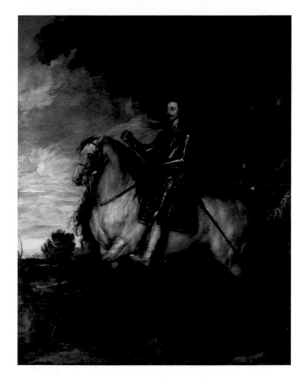

ANTHONY VAN DYCK *Equestrian Portrait of Charles I* ABOUT 1637–8

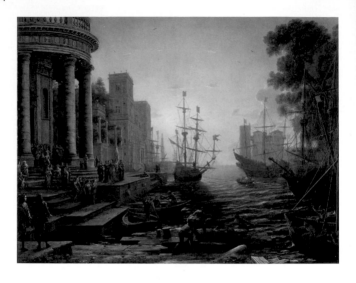

CLAUDE *Seaport with the Embarkation of Saint Ursula* 1641

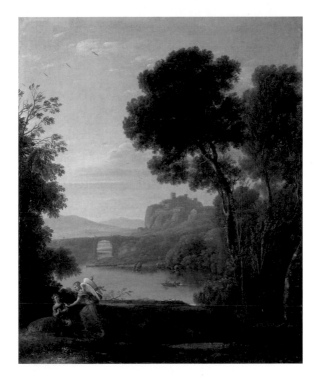

CLAUDE *Landscape with Hagar and the Angel* 1646

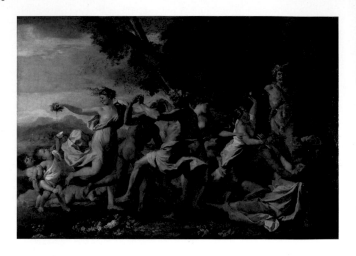

Nicolas Poussin *A Bacchanalian Revel before a Term* 1632–3

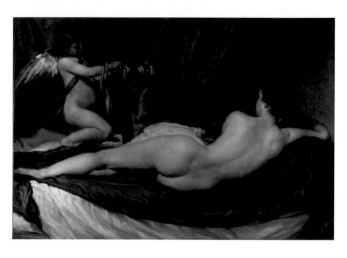

DIEGO VELÁZQUEZ *The Toilet of Venus ('The Rokeby Venus')* 1647–51

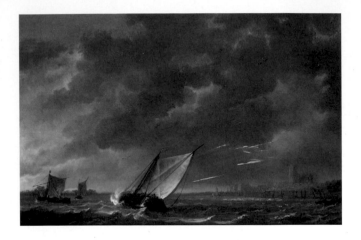

AELBERT CUYP *The Maas at Dordrecht in a Storm* ABOUT 1645–50

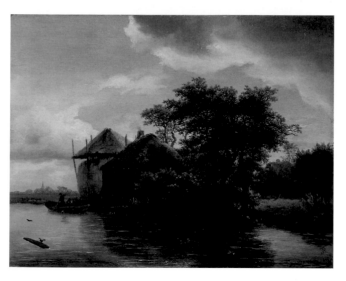

JACOB VAN RUISDAEL *A Cottage and a Hayrick by a River* ABOUT 1646–50

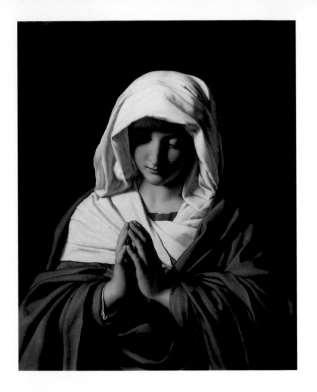

SASSOFERRATO *The Virgin in Prayer* 1640–50

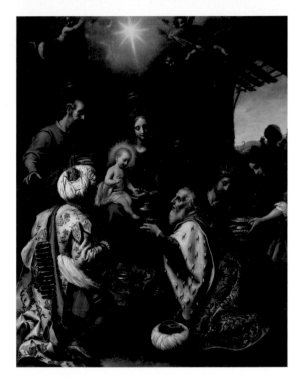

CARLO DOLCI *The Adoration of the Kings* 1649

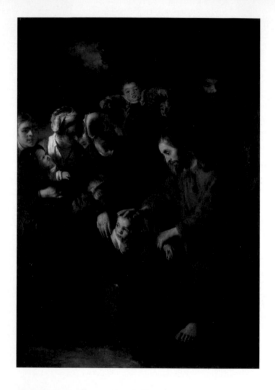

Nicolaes Maes *Christ blessing the Children* 1652–3

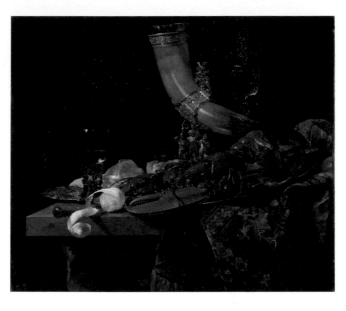

WILLEM KALF *Still Life with Drinking-Horn* ABOUT 1653

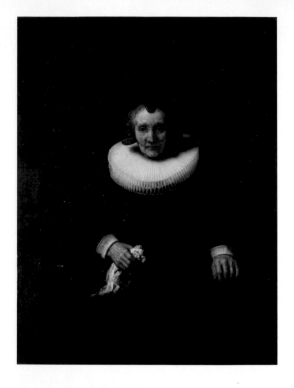

REMBRANDT *Portrait of Margaretha de Geer, Wife of Jacob Trip* ABOUT 1661

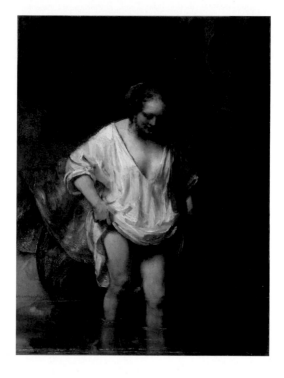

REMBRANDT *A Woman bathing in a Stream (Hendrickje Stoffels?)* 1654

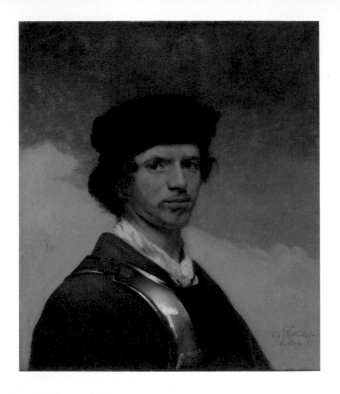

CAREL FABRITIUS *Young Man in a Fur Cap* 1654

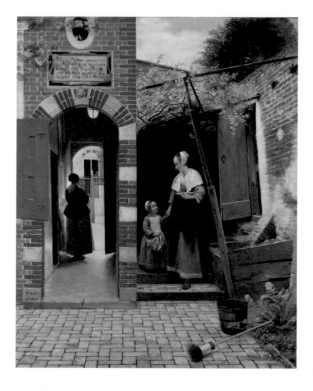

PIETER DE HOOCH *The Courtyard of a House in Delft* 1658

AELBERT CUYP *River Landscape with Horseman and Peasants* ABOUT 1658–60

JAN STEEN *The Effects of Intemperance* ABOUT 1663–5

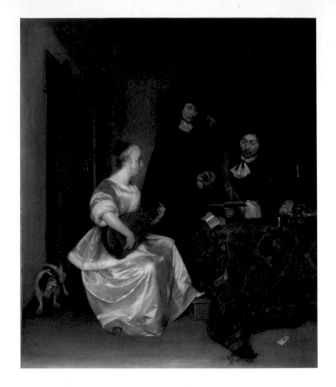

GERARD TER BORCH *A Woman playing a Theorbo to Two Men* ABOUT 1667–8

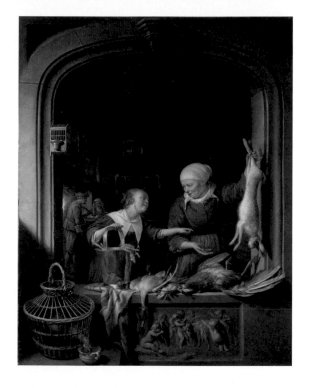

GERRIT DOU *A Poulterer's Shop* ABOUT 1670

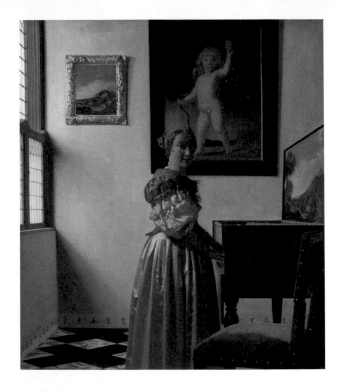

JOHANNES VERMEER *A Young Woman standing at a Virginal* ABOUT 1670–2

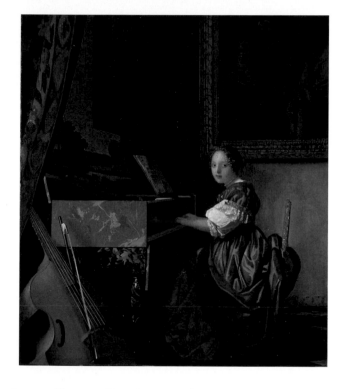

JOHANNES VERMEER *A Young Woman seated at a Virginal* ABOUT 1670–2

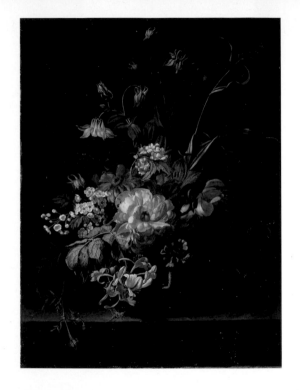

RACHEL RUYSCH *Flowers in a Vase* ABOUT 1685

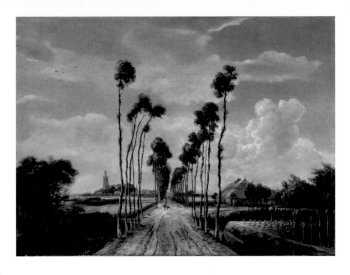

MEINDERT HOBBEMA *The Avenue at Middelharnis* 1689

The East Wing
1700–1900

The pictures representing the last two hundred years of the collection are housed in the East Wing. And immediately on entering this part of the Gallery, visitors will notice a change. Works by eighteenth-century Italian artists such as Canaletto's *Stonemason's Yard* are certainly on display. But the dominance of Italian painters is no longer in evidence. Other national schools of art have come to the fore.

During the eighteenth century powerful figures at the French court such as Madame de Pompadour – depicted in the National Gallery's splendid portrait by Drouais – were keen patrons of home-grown art. A highly decorative and sensuous form of painting was favoured, typified by Boucher's erotically charged mythological scene *Pan and Syrinx*. Later, during the events surrounding the French Revolution which began in 1789 and swept the French monarchy aside, French painting continued to thrive. Jacques-Louis David's spare but very beautiful *Portrait of Jacobus Blauw*, for example, is the depiction of a Dutch diplomat in revolutionary Paris.

Across the Channel, British artists were forging their own distinctive style. Hogarth's *The Graham Children* has a lively freshness to it and a frank lack of sophistication that's quite unlike continental painting. Raeburn's arresting *Archers*, Gainsborough's fashionable *The Morning Walk* and Stubbs's monumental portrait of the horse *Whistlejacket* all attest to a strong attachment to the countryside and outdoor pursuits among those who could afford to commission art.

With art academies now established across Europe – many of which ran annual painting exhibitions – pictures and the artists who created them were seen and discussed – championed or vilified – by the public and the press. Public museums and picture galleries informed tastes, and as the nineteenth century progressed, patrons for art were more likely to buy pictures from exhibitions and picture dealers than from artists themselves. A growing preference among the art-buying public for smaller, more domestically-scaled pictures, encouraged new forms of painting whose subjects reflected the local landscapes and pleasures of their daily lives. Morisot's *Summer's Day*, Renoir's *The Skiff (La Yole)* and Pissarro's *The Boulevard Montmartre at Night* show how the French Impressionists took modern life, and the

capturing of specific light and weather conditions, as their subject. Their luminous combinations of modern, synthetic pigments were taken to further extremes by artists like Van Gogh who imbued the intense contrast of yellows and blues in his *Sunflowers* with personal symbolic meaning. The idea that the artist's personal vision should take precedence over naturalistic representation, along with a fascination with the physical properties of paint, saw painting at the turn of the twentieth century move towards the brink of abstraction. Yet even with a work as mysterious and strange as Cézanne's *Bathers*, its strong link with the art of the past – specifically the grand mythological nudes of sixteenth-century Italy – makes sense of its inclusion in the National Gallery Collection. Just as the founders of the Gallery envisaged back in 1824, viewing such a picture in the context of the entire history of European art allows the viewer both to appreciate where the work has come from and to marvel at the individual creativity it represents.

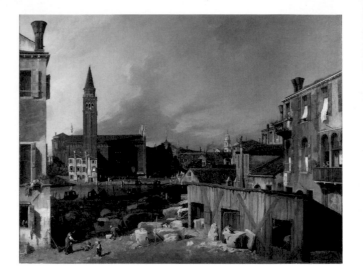

CANALETTO *The Stonemason's Yard* 1727–8

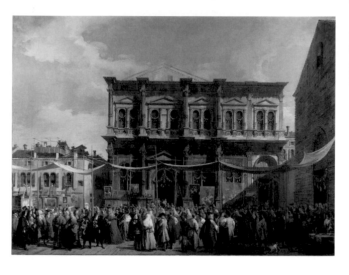

CANALETTO *Venice: The Feast Day of Saint Roch* ABOUT 1735

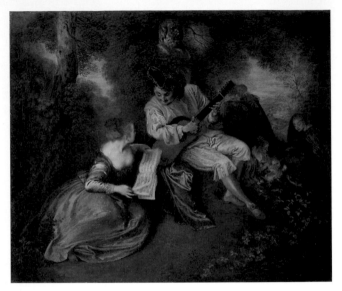

JEAN-ANTOINE WATTEAU *The Scale of Love* 1715–18

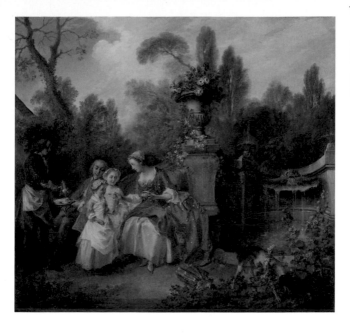

NICOLAS LANCRET
A Lady in a Garden taking Coffee with some Children PROBABLY 1742

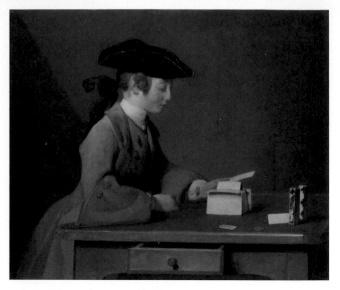

JEAN-SIMÉON CHARDIN *The House of Cards* ABOUT 1736–7

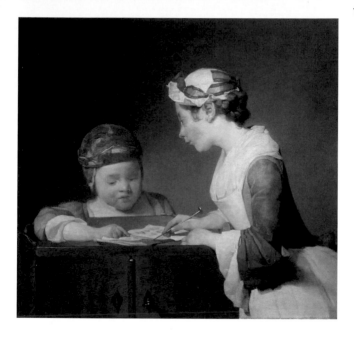

JEAN-SIMÉON CHARDIN *The Young Schoolmistress* PROBABLY 1735–6

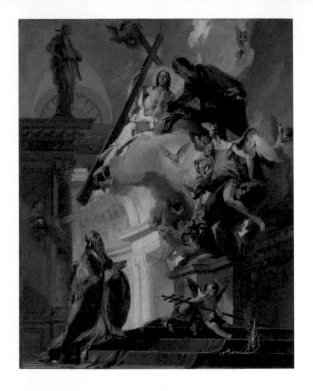

GIOVANNI BATTISTA TIEPOLO *A Vision of the Trinity* ABOUT 1735–9

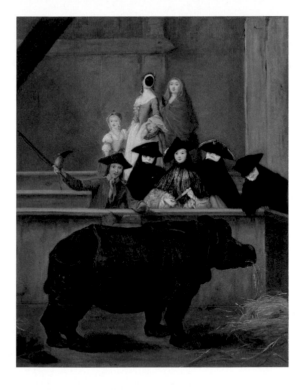

PIETRO LONGHI *Exhibition of a Rhinoceros at Venice* PROBABLY 1751

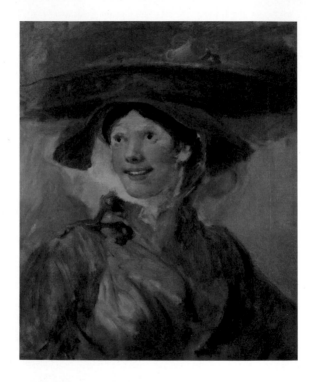

WILLIAM HOGARTH *The Shrimp Girl* ABOUT 1740–5

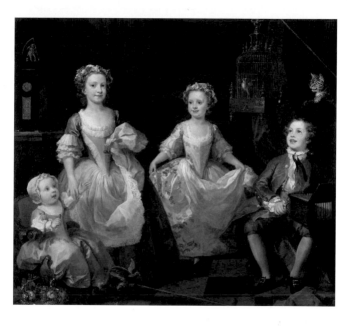

WILLIAM HOGARTH *The Graham Children* 1742

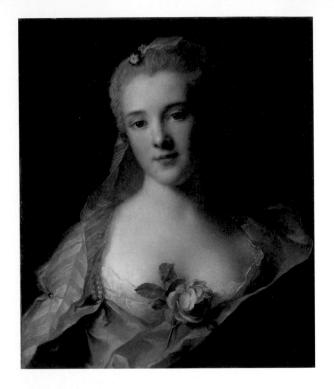

JEAN-MARC NATTIER *Manon Balletti* 1757

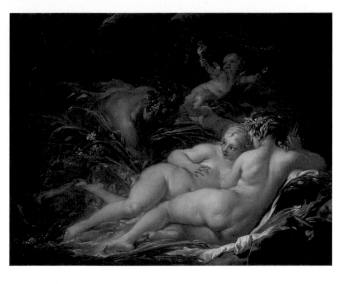

FRANÇOIS BOUCHER *Pan and Syrinx* 1759

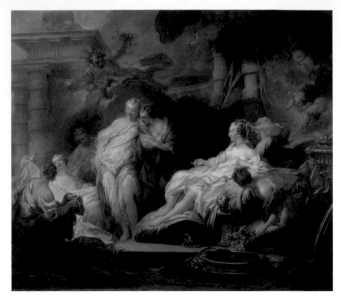

JEAN-HONORÉ FRAGONARD
Psyche showing her Sisters her Gifts from Cupid 1753

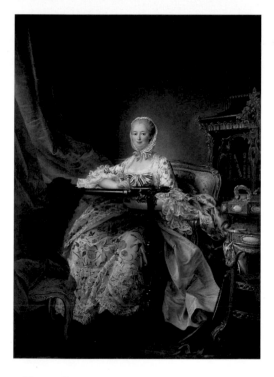

FRANÇOIS-HUBERT DROUAIS
Madame de Pompadour at her Tambour Frame 1763–4

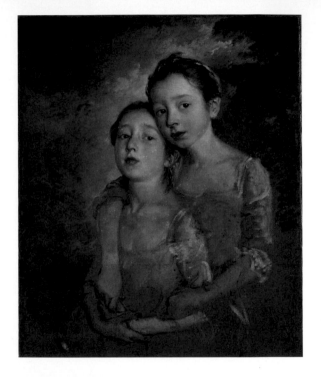

THOMAS GAINSBOROUGH
The Painter's Daughters with a Cat PROBABLY ABOUT 1760–1

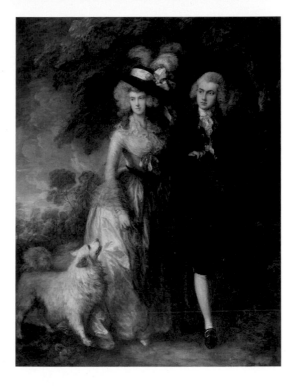

THOMAS GAINSBOROUGH *'The Morning Walk'* 1785

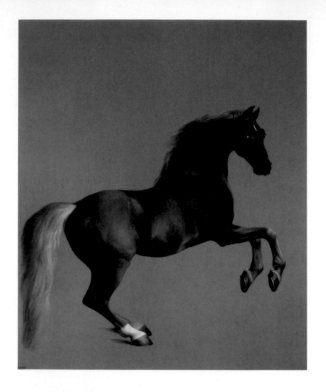

George Stubbs *Whistlejacket* about 1762

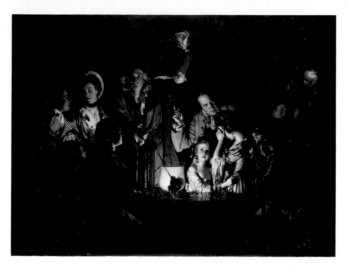

JOSEPH WRIGHT OF DERBY *An Experiment on a Bird in the Air Pump* 1768

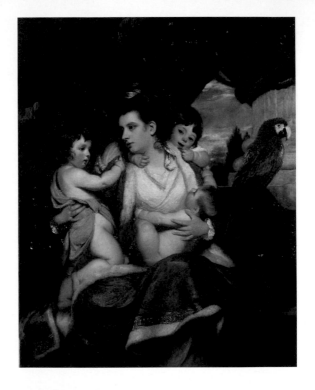

SIR JOSHUA REYNOLDS *Lady Cockburn and her Three Eldest Sons* 1773

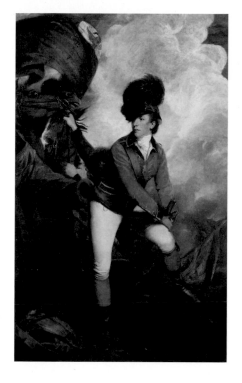

SIR JOSHUA REYNOLDS *Colonel Tarleton* 1782

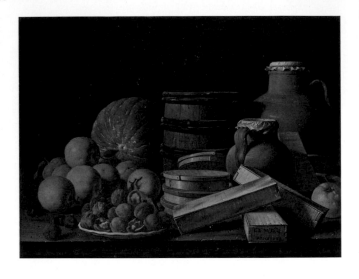

LUIS MELÉNDEZ *Still Life with Oranges and Walnuts* 1772

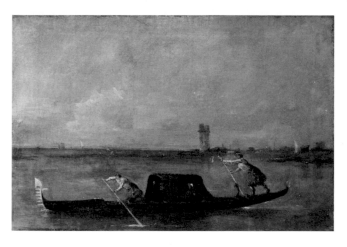

Francesco Guardi *A Gondola on the Lagoon near Mestre* after 1780

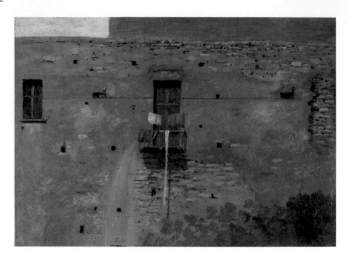

THOMAS JONES *A Wall in Naples* ABOUT 1782

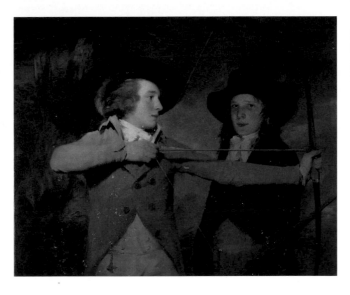

SIR HENRY RAEBURN *'The Archers'* ABOUT 1789–90

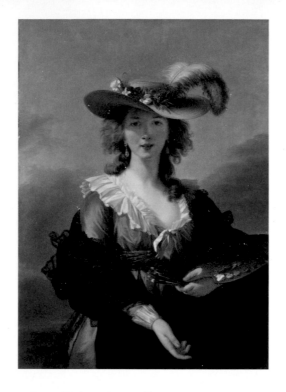

ELIZABETH LOUISE VIGÉE LE BRUN *Self Portrait in a Straw Hat* AFTER 1782

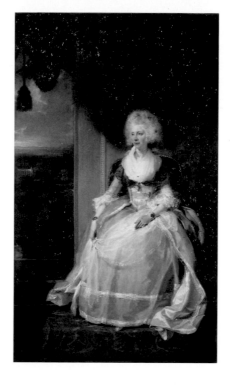

SIR THOMAS LAWRENCE *Queen Charlotte* 1789

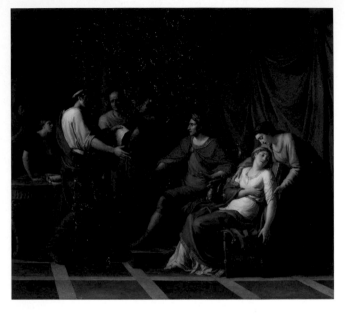

JEAN-JOSEPH TAILLASSON
Virgil reading the Aeneid to Augustus and Octavia 1787

JACQUES-LOUIS DAVID *Portrait of Jacobus Blauw* 1795

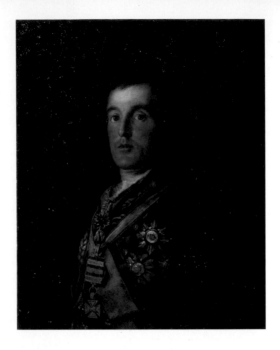

FRANSCISCO DE GOYA *The Duke of Wellington* 1812–14

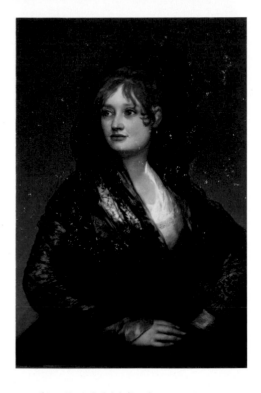

FRANCISCO DE GOYA *Doña Isabel de Porcel* BEFORE 1805

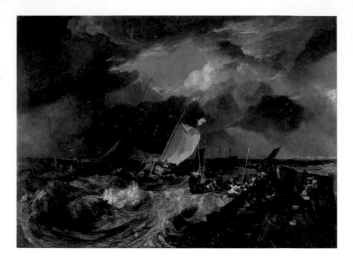

Joseph Mallord William Turner *Calais Pier* 1803

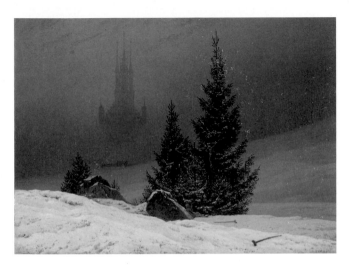

CASPAR DAVID FRIEDRICH *Winter Landscape* PROBABLY 1811

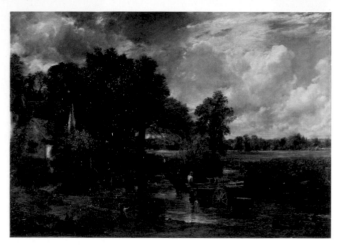

JOHN CONSTABLE *The Hay Wain* 1821

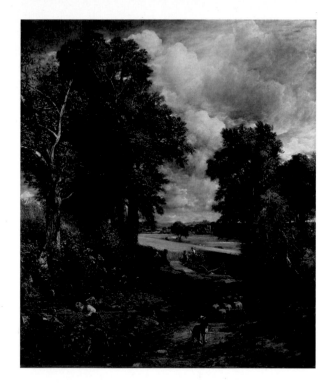

JOHN CONSTABLE *The Cornfield* 1826

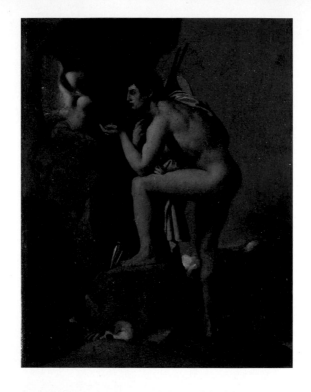

JEAN–AUGUSTE–DOMINIQUE INGRES *Oedipus and the Sphinx* ABOUT 1826

EUGÈNE DELACROIX *Louis-Auguste Schwiter* 1826–30

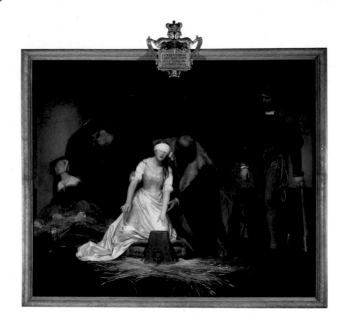

PAUL DELAROCHE *The Execution of Lady Jane Grey* 1833

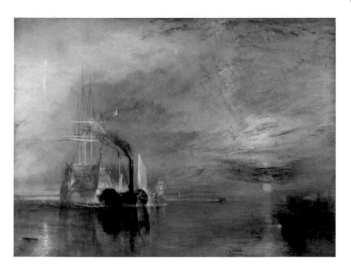

JOSEPH MALLORD WILLIAM TURNER *The Fighting Temeraire* 1839

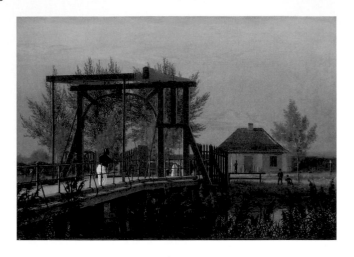

CHRISTEN KØBKE *The Northern Drawbridge to the Citadel in Copenhagen* 1837

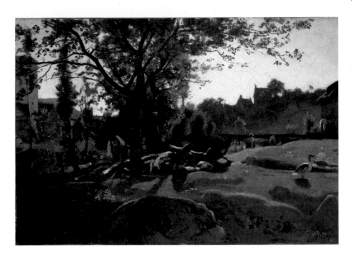

JEAN-BAPTIST-CAMILLE COROT *Peasants under the Trees at Dawn* ABOUT 1840–5

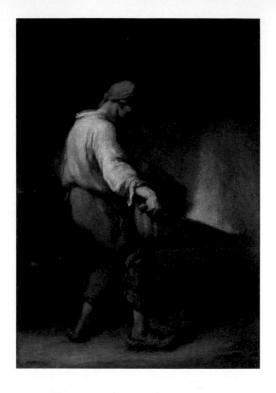

JEAN-FRANÇOIS MILLET *The Winnower* ABOUT 1847–8

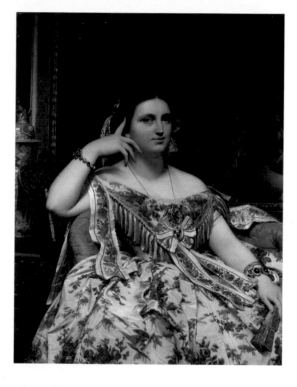

JEAN-AUGUSTE-DOMINIQUE INGRES *Madame Moitessier* 1856

EUGÈNE DELACROIX *Ovid among the Scythians* 1859

GUSTAVE COURBET *Still Life with Apples and a Pomegranate* 1871–2

EDOUARD MANET *The Execution of Maximilian* ABOUT 1867–8

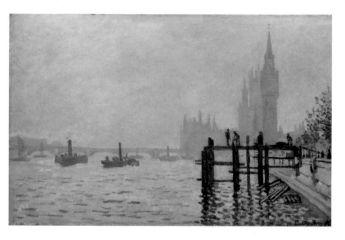

CLAUDE MONET *The Thames below Westminster* ABOUT 1871

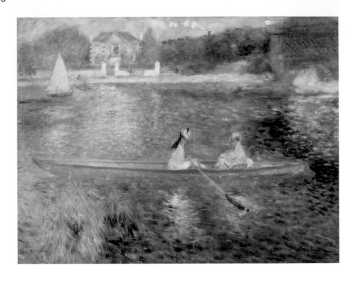

PIERRE-AUGUSTE RENOIR *The Skiff (La Yole)* 1875

BERTHE MORISOT *Summer's Day* ABOUT 1879

Edgar Degas *Miss La La at the Cirque Fernando* 1879

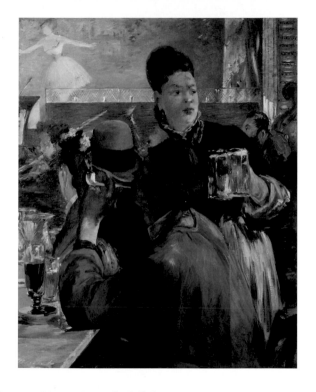

EDOUARD MANET *Corner of a Café-Concert* PROBABLY 1878–80

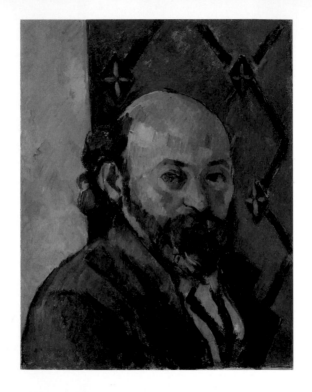

PAUL CÉZANNE *Self Portrait* ABOUT 1880–1

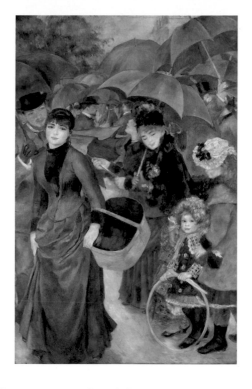

PIERRE-AUGUSTE RENOIR *The Umbrellas* ABOUT 1881–6

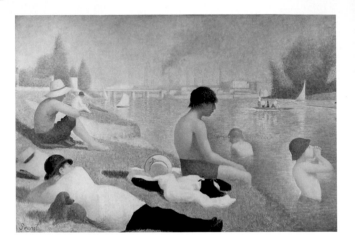

GEORGES SEURAT *Bathers at Asnières* 1884

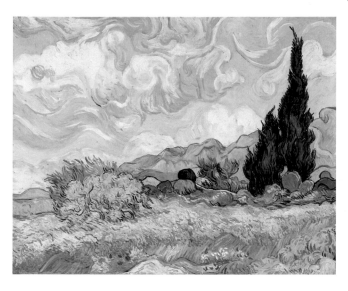

VINCENT VAN GOGH *A Wheatfield, with Cypresses* 1889

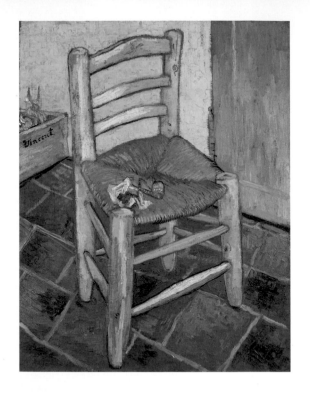

Vincent van Gogh *Van Gogh's Chair* 1888

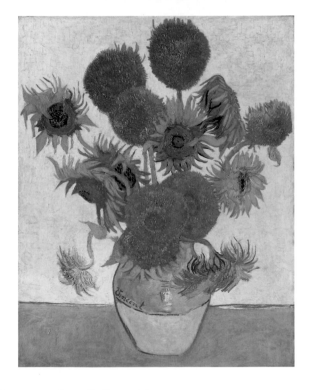

VINCENT VAN GOGH *Sunflowers* 1888

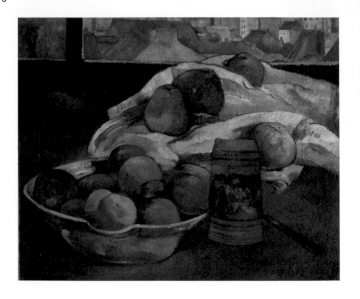

PAUL GAUGUIN *Bowl of Fruit and Tankard before a Window* PROBABLY 1890

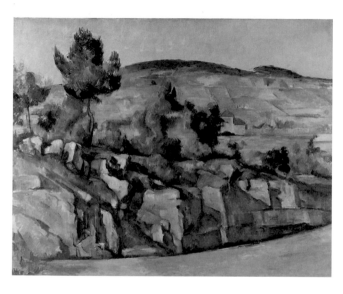

PAUL CÉZANNE *Hillside in Provence* ABOUT 1890–2

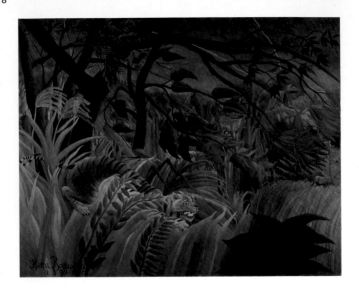

HENRI ROUSSEAU *Surprised!* 1891

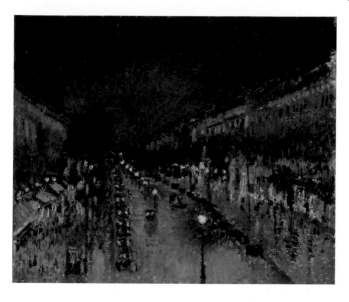

CAMILLE PISSARRO *The Boulevard Montmartre at Night* 1897

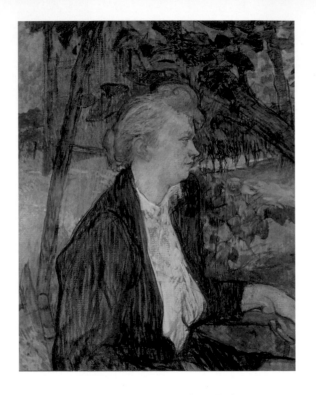

Henri de Toulouse-Lautrec *Woman seated in a Garden* 1891

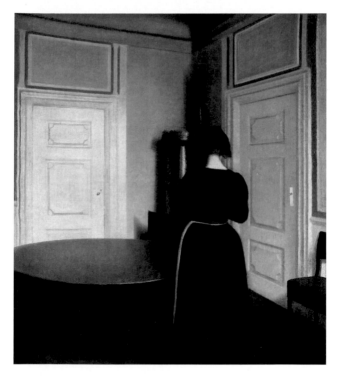

VILHELM HAMMERSHØI *Interior* 1899

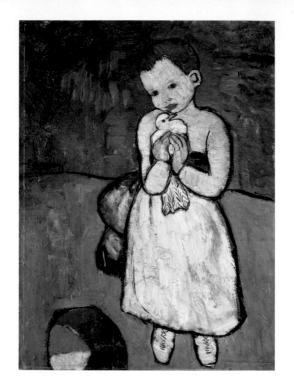

PABLO PICASSO *Child with a Dove* 1901

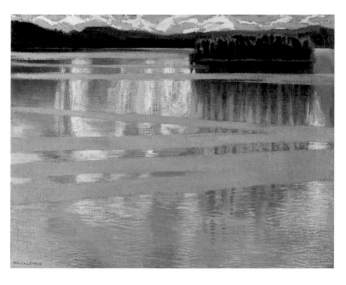

Askeli Gallen-Kallela *Lake Keitele* 1905

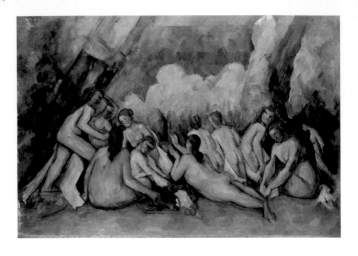

PAUL CÉZANNE *Bathers (Les Grandes Baigneuses)* ABOUT 1894–1905

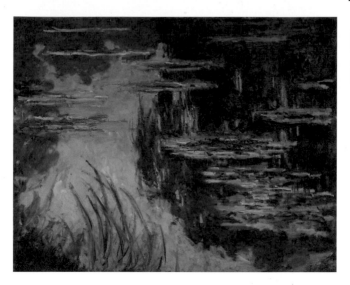

CLAUDE MONET *Water-Lilies, Setting Sun* ABOUT 1907

Index

Bosch, Hieronymus,
living 1474; died 1516
Christ Mocked (The Crowning with Thorns),
about 1490–1500.
Oil on oak, 73.5 x 59.1 cm, p. 66

Botticelli, Sandro, about 1445–1510
Portrait of a Young Man, probably about
1480–5. Tempera and oil on wood,
37.5 x 28.3 cm, p. 50

Venus and Mars, about 1485.
Tempera and oil on poplar,
69.2 x 173.4 cm, p. 51

'Mystic Nativity', 1500.
Oil on canvas, 108.6 x 74.9 cm, p. 64

Boucher, François, 1703–1770
Pan and Syrinx, 1759.
Oil on canvas, 32.4 x 41.9 cm, p. 171

Bouts, Dirk, 1400?–1475
The Entombment, probably 1450s. Glue
tempera on linen, 87.5 x 73.6 cm, p. 33

Portrait of a Man (Jan van Winckele?),
1462. Oil with egg tempera on oak,
31.6 x 20.5 cm, p. 41

Bronzino, 1503–1572
An Allegory with Venus and Cupid,
probably 1540–50.

Oil on wood, 146.1 x 116.2 cm, p. 96

Brueghel the Elder, Jan, 1568–1625
The Adoration of the Kings, 1598.
Bodycolour on vellum, 32.9 x 48 cm,
p. 105

Brugghen, Hendrick ter, 1588–1629
The Concert, about 1626.
Oil on canvas, 99.1 x 116.8 cm, p. 125

Campin, Robert, 1378/9–1444
A Man, about 1435. Oil with egg
tempera on oak, 40.7 x 28.1 cm, p. 26

A Woman, about 1435. Oil with egg
tempera on oak, 40.6 x 28.1 cm, p. 27

Campin, Robert; Follower of,
1378/9–1444
The Virgin and Child before a Firescreen,
about 1440.
Oil with egg tempera on oak with
walnut additions, 63.4 x 48.5 cm, p. 30

Canaletto, 1697–1768
The Stonemason's Yard, 1727–28.
Oil on canvas, 123.8 x 162.9 cm, p. 160

Venice: The Feast Day of Saint Roch,
about 1735.
Oil on canvas, 147.7 x 199.4 cm, p. 161

Caravaggio, Michelangelo Merisi da,
1571–1610
The Supper at Emmaus, 1601.
Oil and tempera on canvas,
141 x 196.2 cm, p. 112

Salome receives the Head of Saint John the Baptist, 1607–10.
Oil on canvas, 91.5 x 106.7 cm, p. 113

Carracci, Annibale, 1560–1609
Christ appearing to Saint Peter on the Appian Way, 1601–2.
Oil on wood, 77.4 x 56.3 cm, p. 111

Cézanne, Paul, 1839–1906
Self Portrait, about 1880–1.
Oil on canvas, 34.7 x 27 cm, p. 210

Hillside in Provence, about 1890–2.
Oil on canvas, 63.5 x 79.4 cm, p. 217

Bathers (Les Grandes Baigneuses),
about 1894–1905.
Oil on canvas, 127.2 x 196.1 cm, p. 224

Champaigne, Philippe de, 1602–1674
Cardinal de Richelieu, 1633–40.
Oil on canvas, 259.5 x 178.5 cm, p. 127

Chardin, Jean-Siméon, 1699–1779
The Young Schoolmistress, probably 1735–6.
Oil on canvas, 61.6 x 66.7 cm, p. 165

The House of Cards, about 1736–7.
Oil on canvas, 60.3 x 71.8 cm, p. 164

Cimabue, about 1240–1302
The Virgin and Child Enthroned with Two Angels, about 1265–80. Egg tempera on wood, 25.7 x 20.5 cm, p. 16

Claude, 1604/5?–1682
Seaport with the Embarkation of Saint Ursula, 1641.
Oil on canvas, 112.9 x 149 cm, p. 134

Landscape with Hagar and the Angel, 1646.
Oil on canvas mounted on wood,
52.2 x 42.3 cm, p. 135

Constable, John, 1776–1837
The Hay Wain, 1821. Oil on canvas,
130.2 x 185.4 cm, p. 192

The Cornfield, 1826. Oil on canvas,
143 x 122 cm, p. 193

Corot, Jean-Baptiste Camille,
1796–1875
Peasants under the Trees at Dawn,
about 1840–5.
Oil on canvas, 28.2 x 39.7 cm, p. 199

Correggio, active 1494; died 1534
Venus with Mercury and Cupid ('The School of Love'), about 1525.

Oil on canvas, 103.5 x 141 cm, p. 155

Hogarth, William, 1697–1764
The Shrimp Girl, about 1740–5.
Oil on canvas, 63.5 x 52.5 cm, p. 168

The Graham Children, 1742.
Oil on canvas, 160.5 x 181 cm, p. 169

Holbein the Younger, Hans,
1497/8–1543
*A Lady with a Squirrel and a Starling
(Anne Lovell?),* about 1526–8.
Oil on oak, 56 x 38.8 cm, p. 94

The Ambassadors, 1533
Oil on oak, 207 x 209.5 cm, p. 95

Honthorst, Gerrit van, 1592–1656
Christ before the High Priest, about 1617.
Oil on canvas, 272 x 183 cm, p. 120

Hooch, Pieter de, 1629–1684
The Courtyard of a House in Delft, 1658.
Oil on canvas, 73.5 x 60 cm, p. 147

Ingres, Jean-Auguste-Dominique,
1780–1867
Oedipus and the Sphinx, about 1826.
Oil on canvas, 17.5 x 13.7 cm, p. 194

Madame Moitessier, 1856.
Oil on canvas, 120 x 92.1 cm, p. 201

Jones, Thomas, 1742–1803
A Wall in Naples, about 1782.
Oil on paper laid down on canvas,
11.4 x 16 cm, p. 182

Kalf, Willem, 1619–1693
Still Life with the Drinking-Horn,
about 1653.
Oil on canvas, 86.4 x 102.2 cm, p. 143

Købke, Christen, 1810–1848
*The Northern Drawbridge to the Citadel in
Copenhagen,* 1837.
Oil on canvas, 44.2 x 65.1 cm, p. 198

Lancret, Nicolas, 1690–1743
*A Lady in a Garden taking Coffee with
some Children,* probably 1742.
Oil on canvas, 88.9 x 97.8 cm, p. 163

Lastman, Pieter, 1583–1633
Juno discovering Jupiter with Io, 1618.
Oil on wood, 54.3 x 77.8 cm, p. 119

Lawrence, Thomas, 1769–1830
Queen Charlotte, 1789.
Oil on canvas, 239.5 x 147 cm, p. 185

Leonardo da Vinci, 1452–1519
The Virgin of the Rocks, about 1491–1508.
Oil on wood, 189.5 x 120 cm
Part of group: Panels from the
S. Francesco Altarpiece, Milan, p. 55

Raphael, 1483–1520
Saint Catherine of Alexandria, about 1507.
Oil on wood, 72.2 x 55.7 cm, p. 73

Portrait of Pope Julius II, mid 1511.
Oil on poplar, 108.7 x 81 cm, p. 74

Rembrandt, 1606–1669
Saskia van Uylenburgh in Arcadian Costume, 1635.
Oil on canvas, 123.5 x 97.5 cm, p. 130

Self Portrait at the Age of 34, 1640.
Oil on canvas, 102 x 80 cm, p. 131

A Woman bathing in a Stream (Hendrickje Stoffels?), 1654.
Oil on oak, 61.8 x 47 cm, p. 145

Portrait of Margaretha de Geer, Wife of Jacob Trip, about 1661.
Oil on canvas, 130.5 x 97.5 cm, p. 144

Renoir, Pierre-Auguste, 1841–1919
The Skiff (La Yole), 1875.
Oil on canvas, 71 x 92 cm, p. 206

The Umbrellas, about 1881–6.
Oil on canvas, 180.3 x 114.9 cm, p. 211

Reynolds, Sir Joshua, 1723–1792
Lady Cockburn and her Three Eldest Sons, 1773.

Oil on canvas, 141.5 x 113 cm, p. 178

Colonel Tarleton, 1782.
Oil on canvas, 236 x 145.5 cm, p. 179

Rousseau, Henri, 1844–1910
Surprised!, 1891.
Oil on canvas, 129.8 x 161.9 cm, p. 218

Rubens, Peter Paul, 1577–1640
Samson and Delilah, about 1609–10.
Oil on wood, 185 x 205 cm, p. 116

Portrait of Susanna Lunden(?) ('Le Chapeau de Paille'), probably 1622–5.
Oil on oak, 79 x 54.6 cm, p. 122

A View of Het Steen in the Early Morning, probably 1636.
Oil on oak, 131.2 x 229.2 cm, p. 132

Ruisdael, Jacob van, 1628/9?–1682
A Cottage and a Hayrick by a River, about 1646–50.
Oil on oak, 26 x 33.4 cm, p. 139

Ruysch, Rachel, 1664–1750
Flowers in a Vase, about 1685.
Oil on canvas, 57 x 43.5 cm, p. 154

Sarto, Andrea del, 1486–1530
Portrait of a Young Man, about 1517–18.
Oil on linen, 72.4 x 57.2 cm, p. 87

Photographic credits

All photographs © The National Gallery 2008,
except p. 222 © Succession Picasso / DACS London 2008

Front cover: Rogier van der Weyden, *The Magdalen Reading* (detail), before 1438 (p. 31)
Page 2: English or French School, *The Wilton Diptych* (detail), about 1395-9 (p. 20)
Back cover: Vincent van Gogh, *Van Gogh's Chair* (detail), 1888 (p. 214)

First published in Great Britain in 2008 by National Gallery Company Limited
St Vincent House
30 Orange Street
London WC2H 7HH
www.nationalgallery.co.uk

ISBN: 978 1 85709 447 3
525535

British Library Cataloguing-in-Publication Data. A catalogue record is available from
the British Library.
Library of Congress Control Number: 2008934483

Publisher *Louise Rice*
Editors *Davida Saunders and Claire Young*
Production *Jane Hyne and Penny Le Tissier*
Designed by *Gabriella Le Grazie*
Printed in Hong Kong by Printing Express